Copyright Year: 2023

Copyright Notice: by Heather Wylie. All rights reserved. The scanning, uploading, and distribution of this book without permission is theft of the author's intellectual property. If you would like permission to use material from the book (except in the case of brief quotations embodied in critical articles and review) you need the written permission of the author. Thank you for supporting the author's rights.

Heather Wylie
www.hwylieart.com

Because the internet is dynamic in nature, any web addresses or links may have changed since the publication and may no longer be valid. The views expressed in this work are those of the author.

First Edition
ISBN 978-1-387-22324-4
Imprint: Lulu.com
The above information forms this copyright notice: © 2023 by Heather Wylie. All rights reserved.

For Harrison Wayne Knappe, my sweet little bear.

Author Note: It's important to leave our animal friends alone. The best way that we can appreciate them is from a distance in their own space. When we go into nature we are a guest in the houses of our animal friends. It is important to be a polite guest.

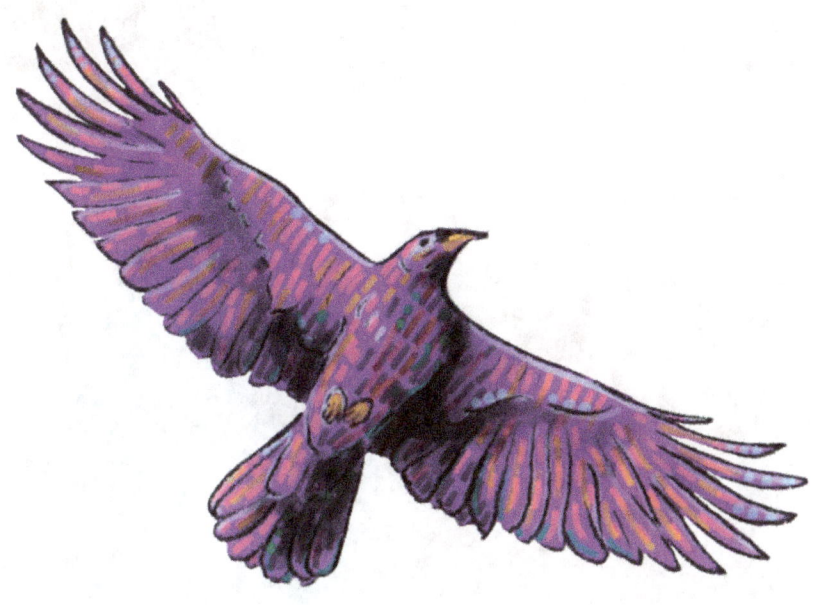

ANIMAL FRIENDS

of West Texas

written and illustrated
by Heather Wylie Knappe

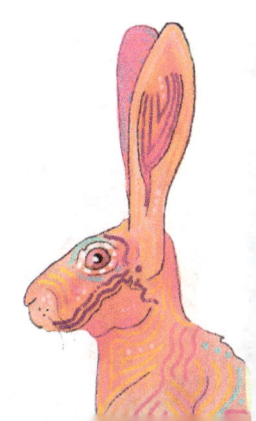

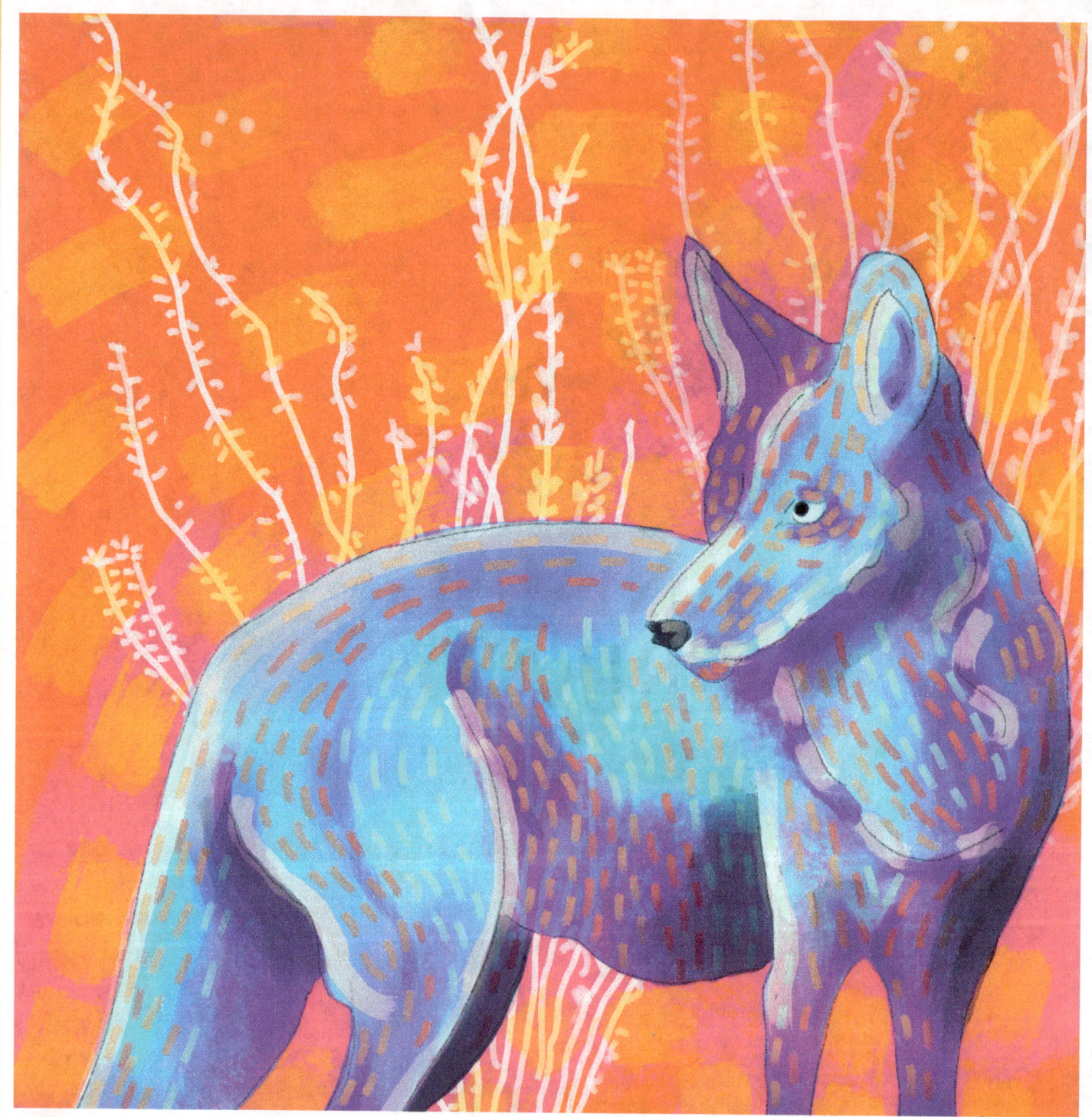

If you go on a West Texas adventure you can see many animals! Keep an eye out for Coyote, or the "song dog," who is known for his yipping and howls. Coyote will also squeal, bark, and huff - he makes lots of noises! If you see him, you might think that he is a wolf or a dog - that's because he's a relative! Our friend Coyote isn't a picky eater, he'll eat almost anything, but that doesn't mean that you want to give him people food. Coyote tends to be awake when you're asleep, but if you listen closely, you might be able to hear him sing you a lullaby.

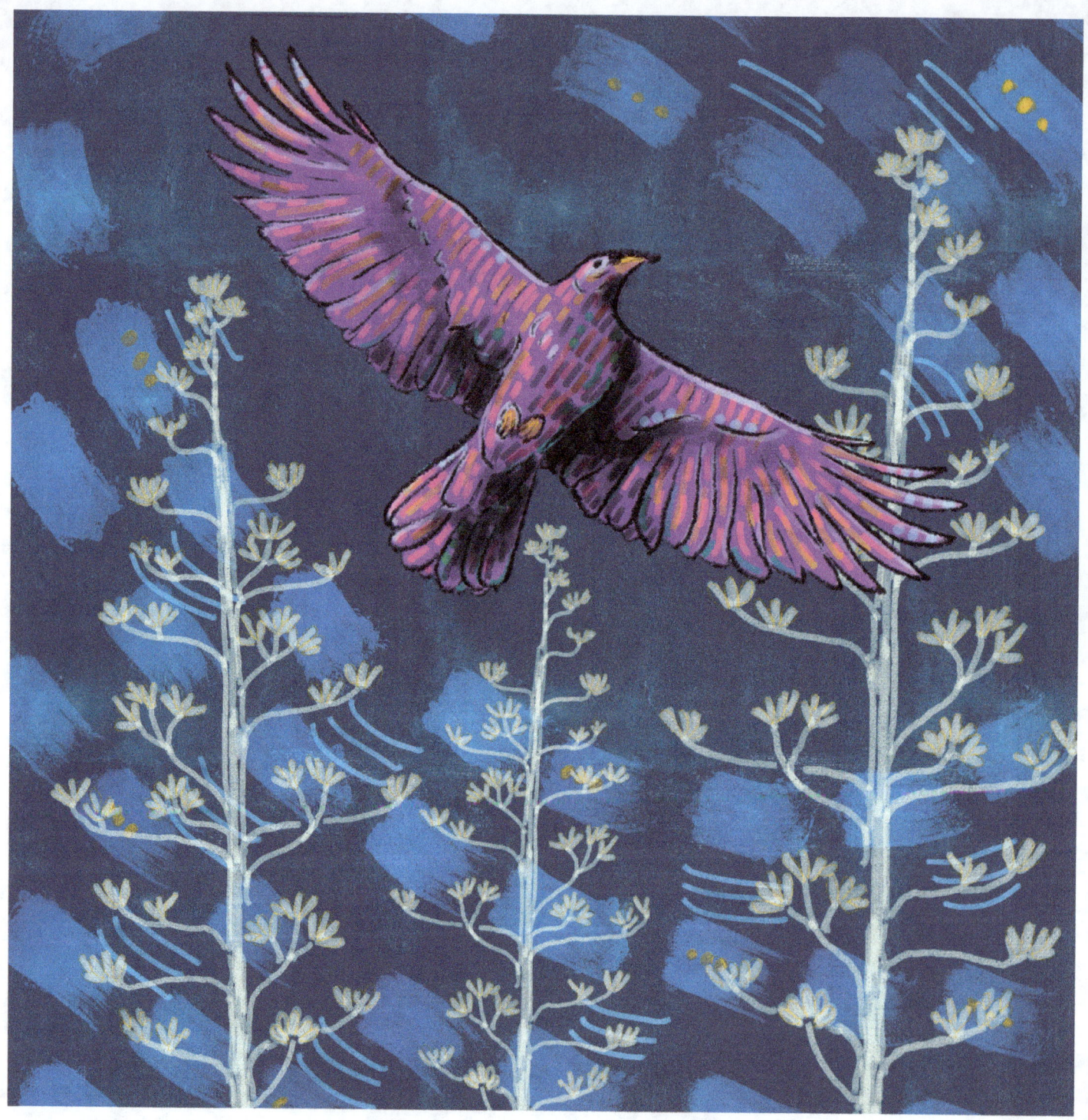

The Chihuahuan raven lives mostly in the Southwestern United States and Mexico. She will often travel in a flock - a group of lots of other birds. She will even fly as a pair with another raven. She likes to build her nest in big trees, old buildings, and even on top of electric poles. She is a medium sized bird. She is very smart! She can be taught to "talk" and can repeat back different phrases and sing! What would you teach your friend Raven to sing?

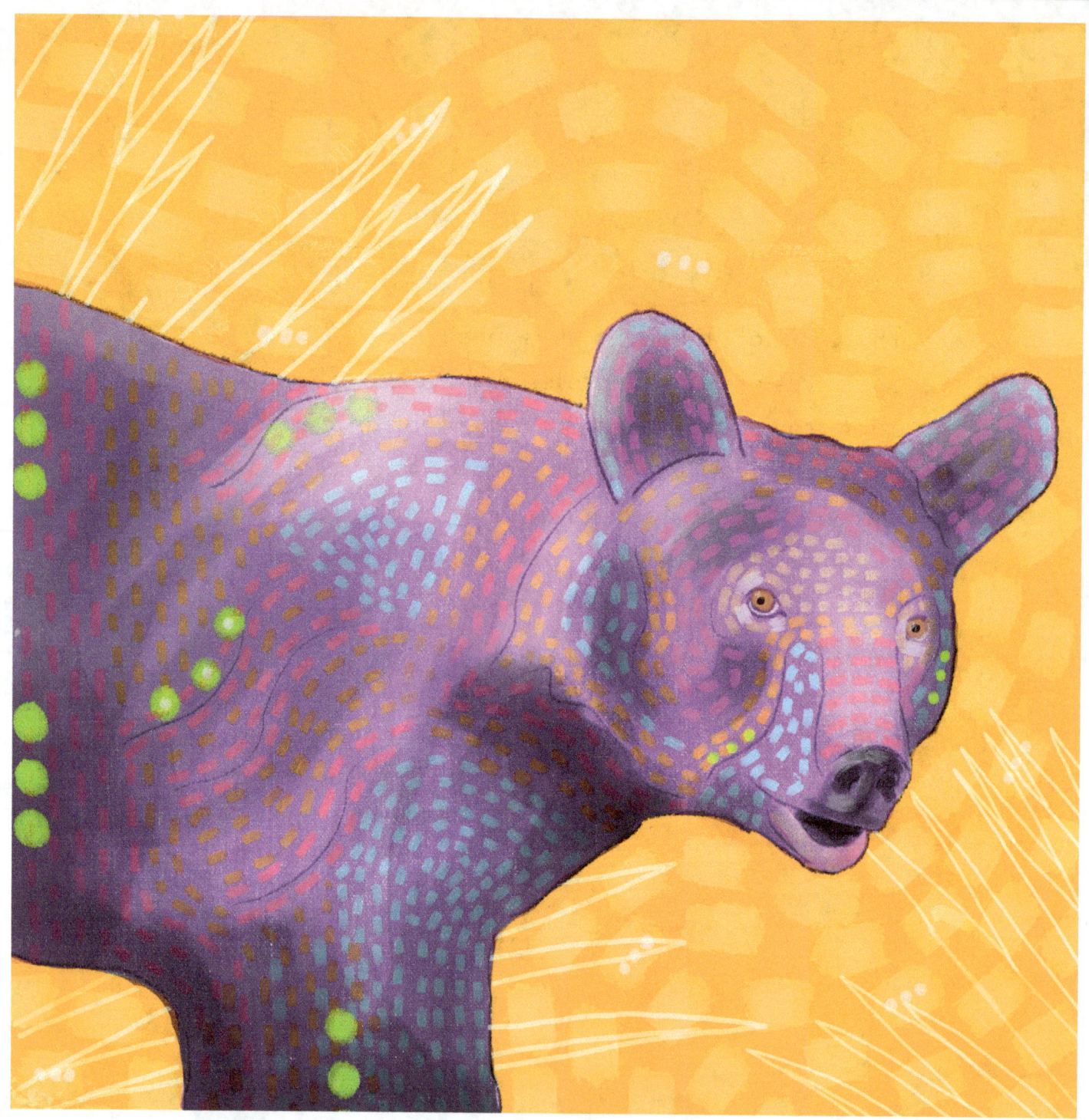

The Mexican Black Bear is a medium sized bear that has been recorded in several Mexican states and in Texas. She enjoys eating nuts, berries, prickly pear fruit, plant roots, as well as insects and small animals. She lives in a den, which can be a cave or even a hollowed out tree. As a mother, she will have two or three cubs at a time. If you see your friend Bear be sure to wave hello, but leave her alone. She is a protected animal in Texas - this means it's against the law to interact with her or hurt her.

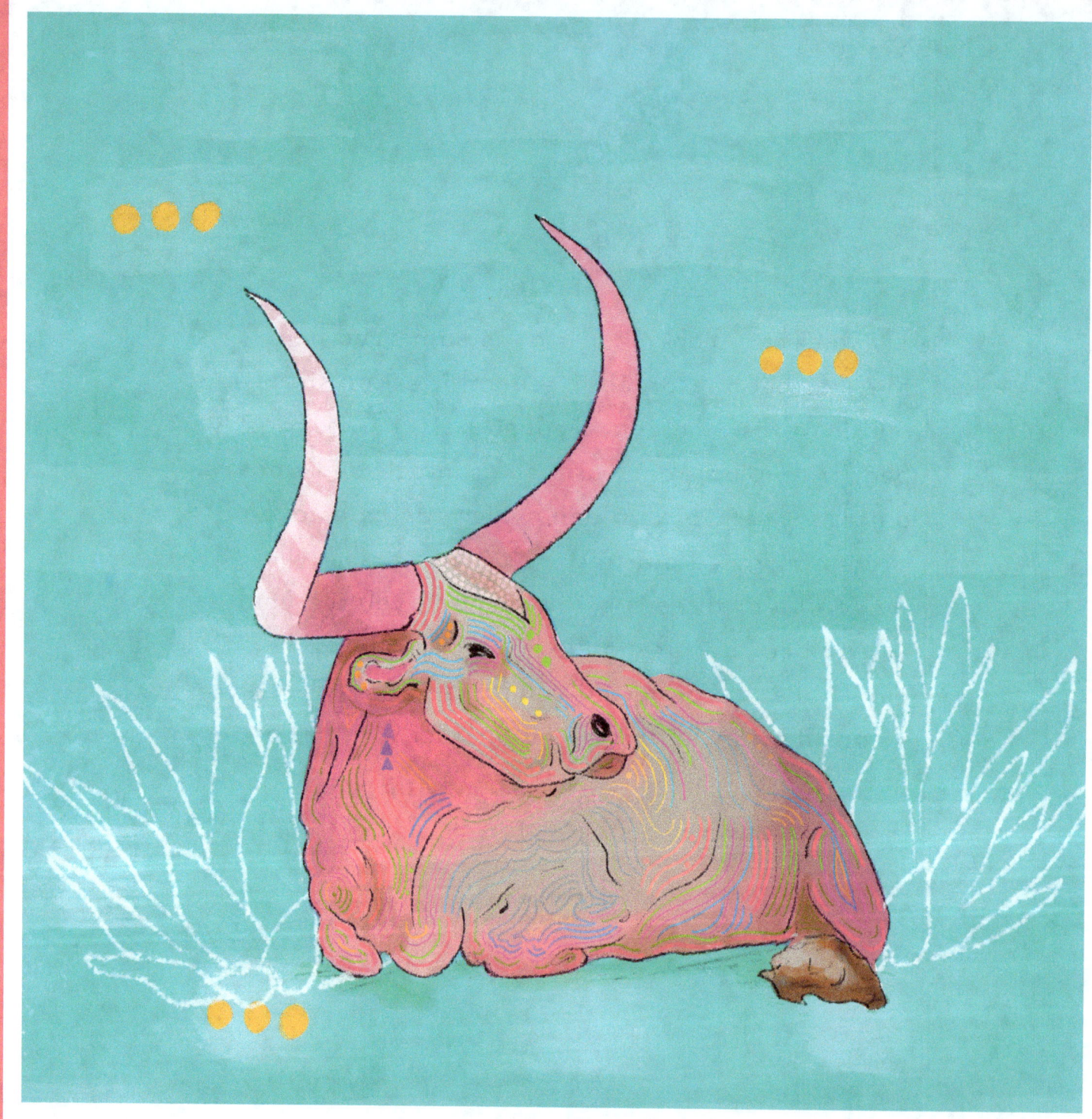

Longhorn loves to forage for yummy plants to eat. Did you know he can go for days without drinking any water? That makes him perfect for the ranges of Texas! No two longhorns look the same, but he is easy to spot because of the long horns that grow on the top of his head - sometimes the horns are over seven feet long! Both bulls and cows have horns. Our friend almost disappeared completely in the 1920s, but was saved by several families and the United States government. You can find your friend Longhorn in different parts of the state today and if you listen closely he might even say "moo" to you!

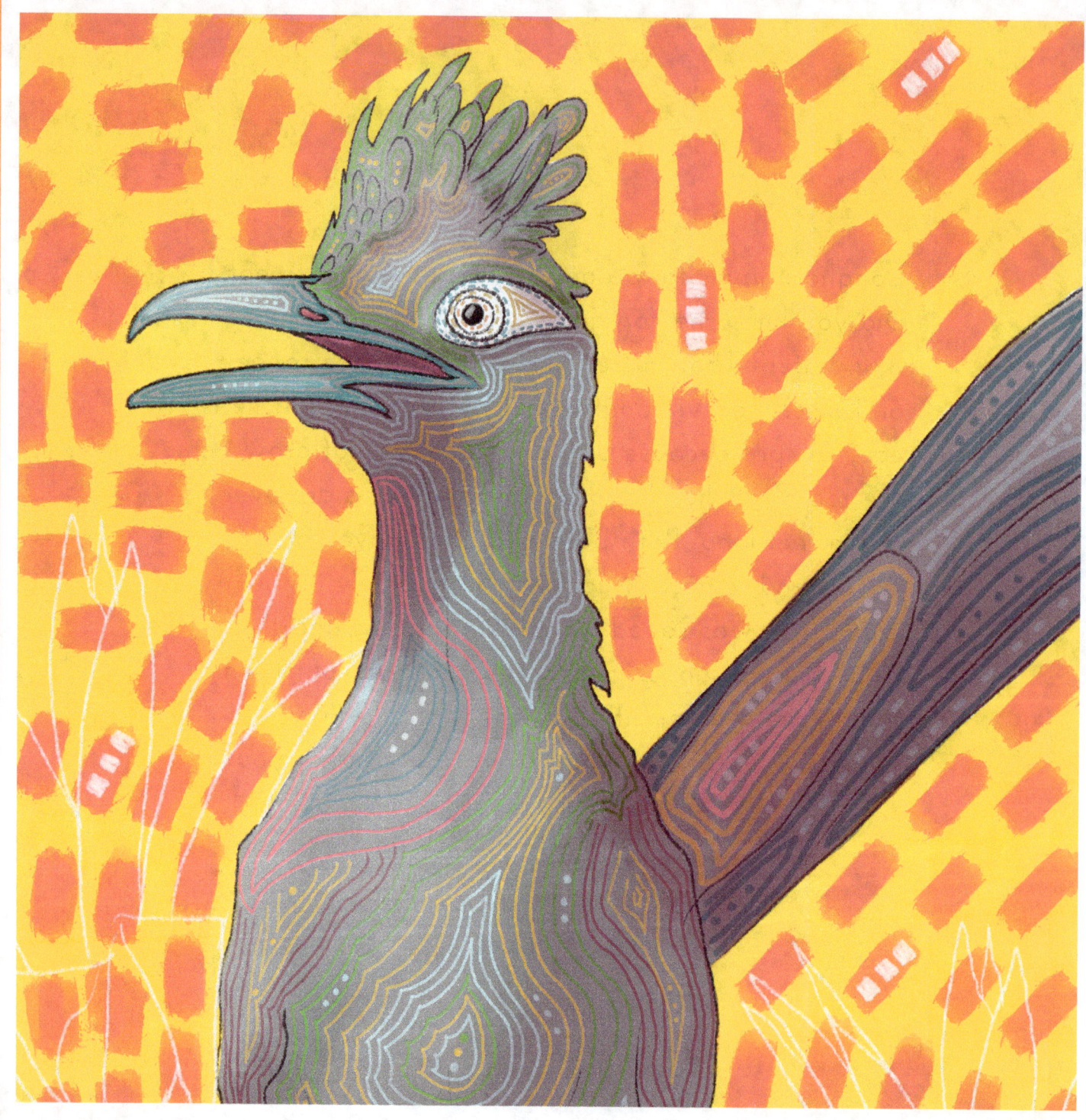

Roadrunner is part of the cuckoo bird family. He is best known for his ability to run - and can reach speeds up to 15 miles per hour! You won't see him fly like other birds. He's known for gliding or for flying very short distances. Our friend Roadrunner is an omnivore; he will eat snakes, small mammals, and plants. He is the perfect desert bird for West Texas. He can absorb water from his food into his own body. He is very social, so he might approach you, but it's important to remember to say "hello" from a distance.

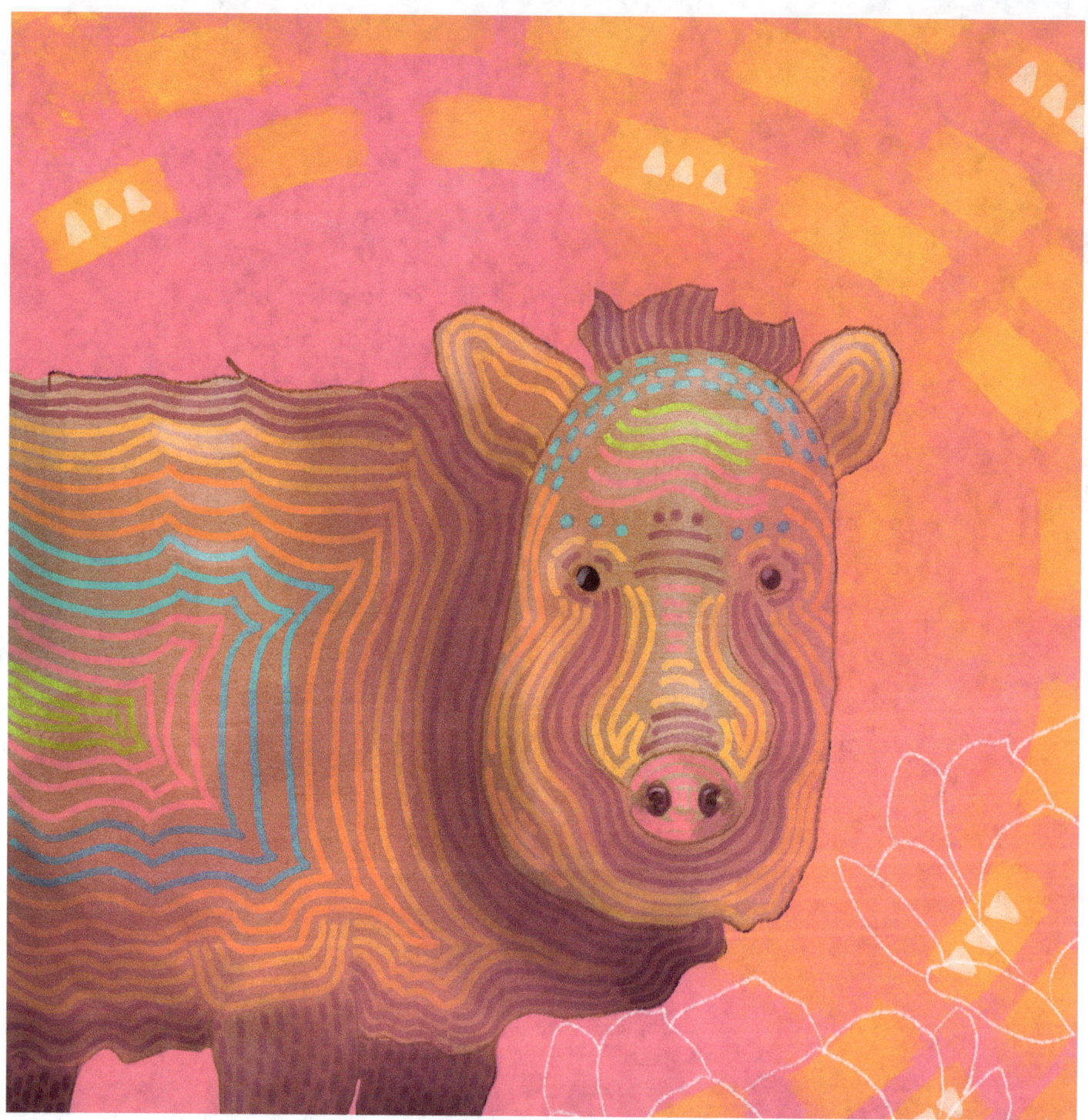

The javelina, or collared peccary, is an animal that looks like a pig but is not a pig. Pigs were introduced to the Americas by Europeans, but javelinas are a native species. Javelina lives in desert areas with lots of different plants for her to eat. She loves to eat prickly pear cactus, mesquite beans, and other plant matter. Sometimes she will even eat small animals - like lizards. Our friend has to share her favorite foods because Javelina doesn't live alone. She can be found with her family group, which can have a dozen family members (but there have been herds seen with as many as fifty individuals).

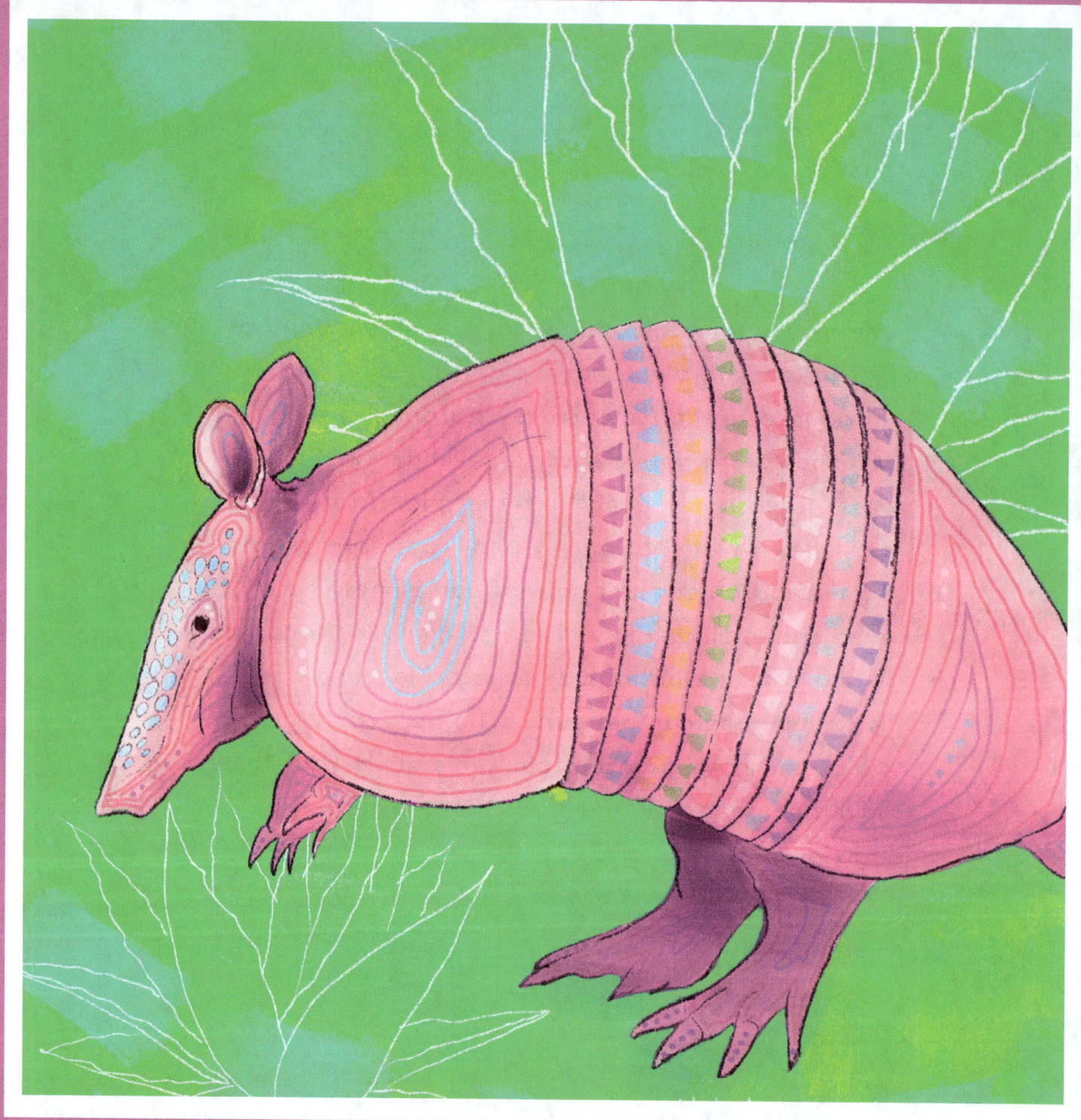

The armored armadillo is native to the Americas and is a close relative of anteaters and sloths. Our West Texas friend is called "nine-banded," but might have seven to eleven bands on her armored body. Some people think Armadillo can roll into a ball, but only her cousins (three-banded armadillos) can. Her long claws are perfect for digging when she forages for insects to eat. Armadillo is known for her ability to leap three to four feet in the air when she is startled. How high can you leap? As a mother, she will always have four identical babies per litter! Imagine having three other siblings who look just like you!

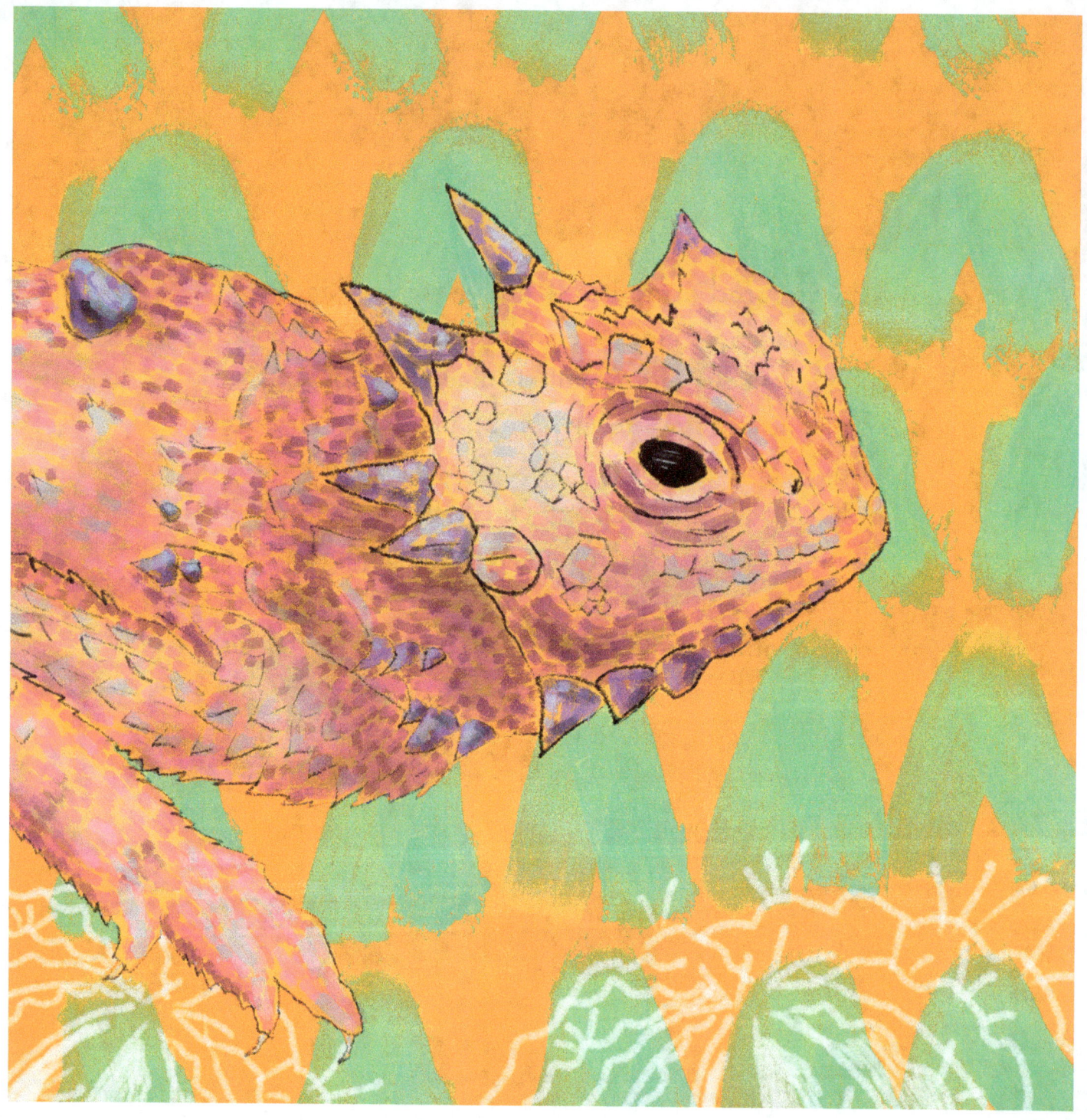

The horned toad or horny toad is called a "toad" because of his flat, round body. He is actually a lizard! He is about five inches or less in length. Horny Toad loves to eat red harvester ants. Do you want to eat red harvester ants? The color of this unique reptile allows him to blend into the vegetation and landscape of West Texas. He has interesting defense mechanisms to protect him when he doesn't feel safe: he can shoot blood out of his eyelid and he can puff his body up with air to make himself seem much bigger!

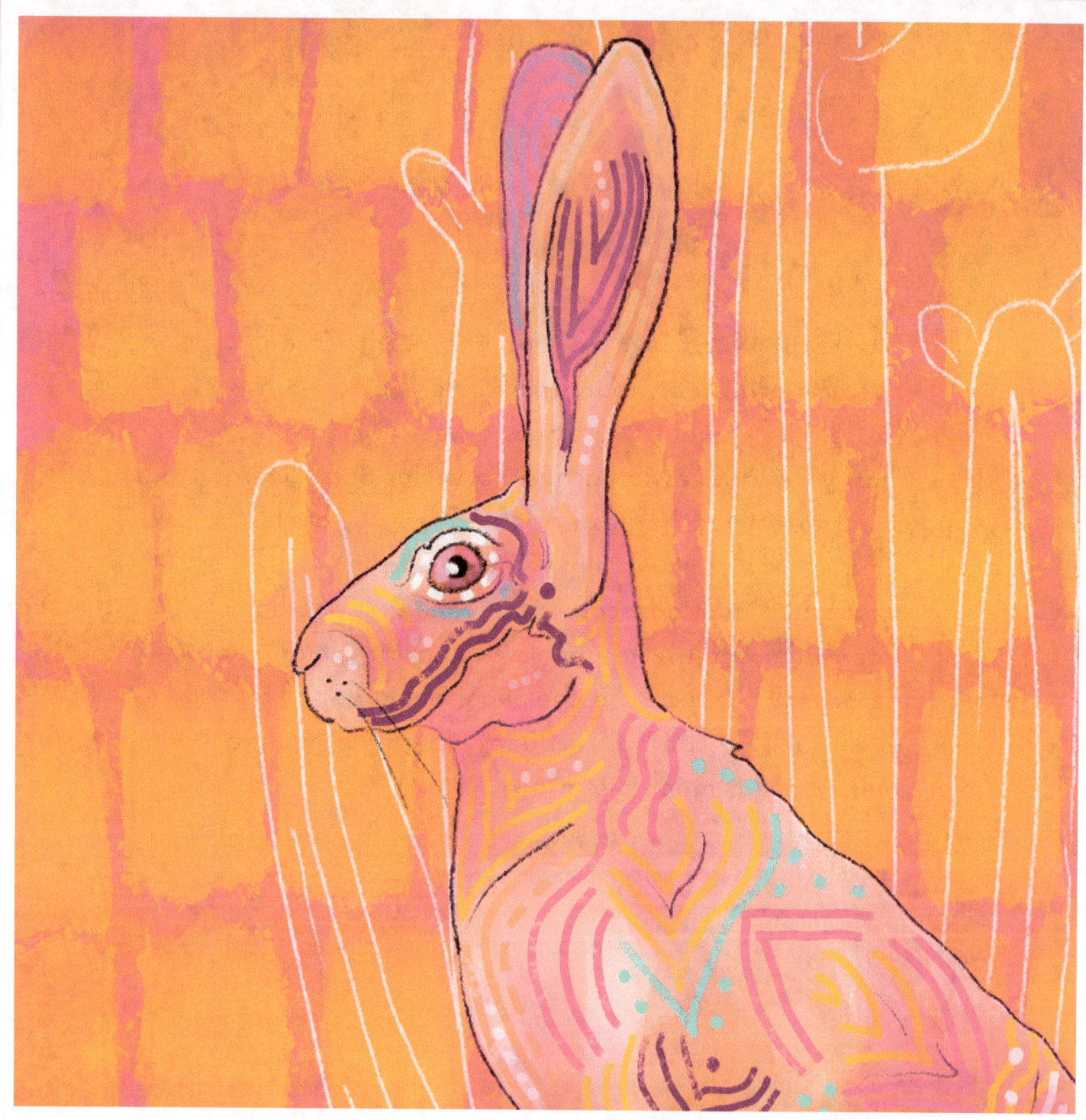

The Texas jackrabbit can be found in both the grasslands of the state and in the desert. She likes to eat various kinds of vegetation like grass and cacti. Look at her long ears! She uses her long ears and her big eyes to remain watchful of her surroundings. If Jackrabbit sees something that makes her nervous, like our friend Coyote, she will quickly run away. She is a fast runner and will flash her tail (which has a bright white underside) to alert other jackrabbits to danger if they are nearby.

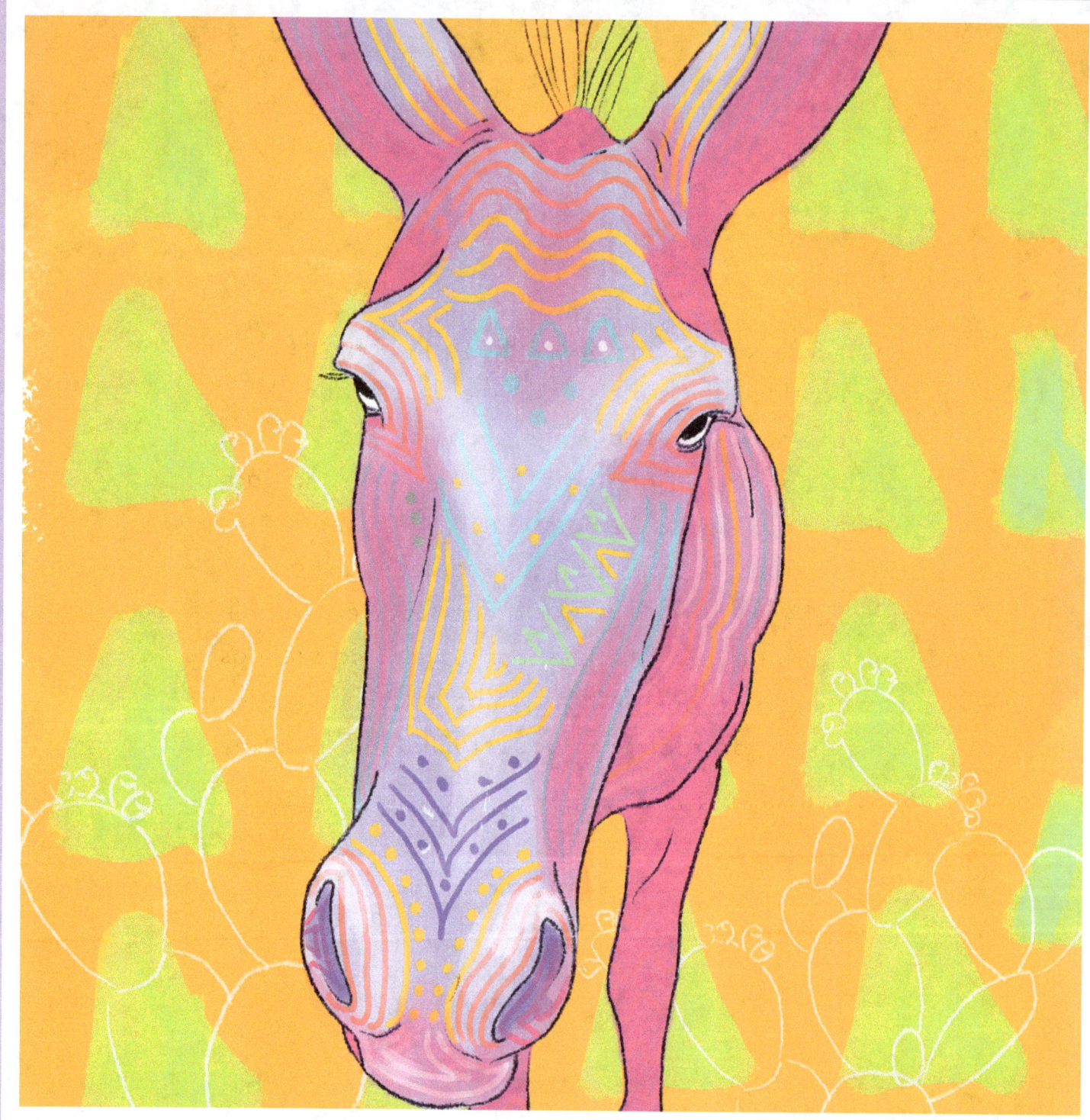

On your travels through West Texas you might even see a wild burro! The wild burros of the Big Bend left their original owners or came to Texas from Mexico. Our friend Burro is feral. That means he's a wild animal. An animal can become feral when they leave their home with people. He does compete with native animals for food in the Big Bend National Park. He can make it hard for other animals to find plenty of food to eat and drink. Burro is a social animal and doesn't like to be alone. He can be found traveling around far West Texas with other burro friends and even wild horses!

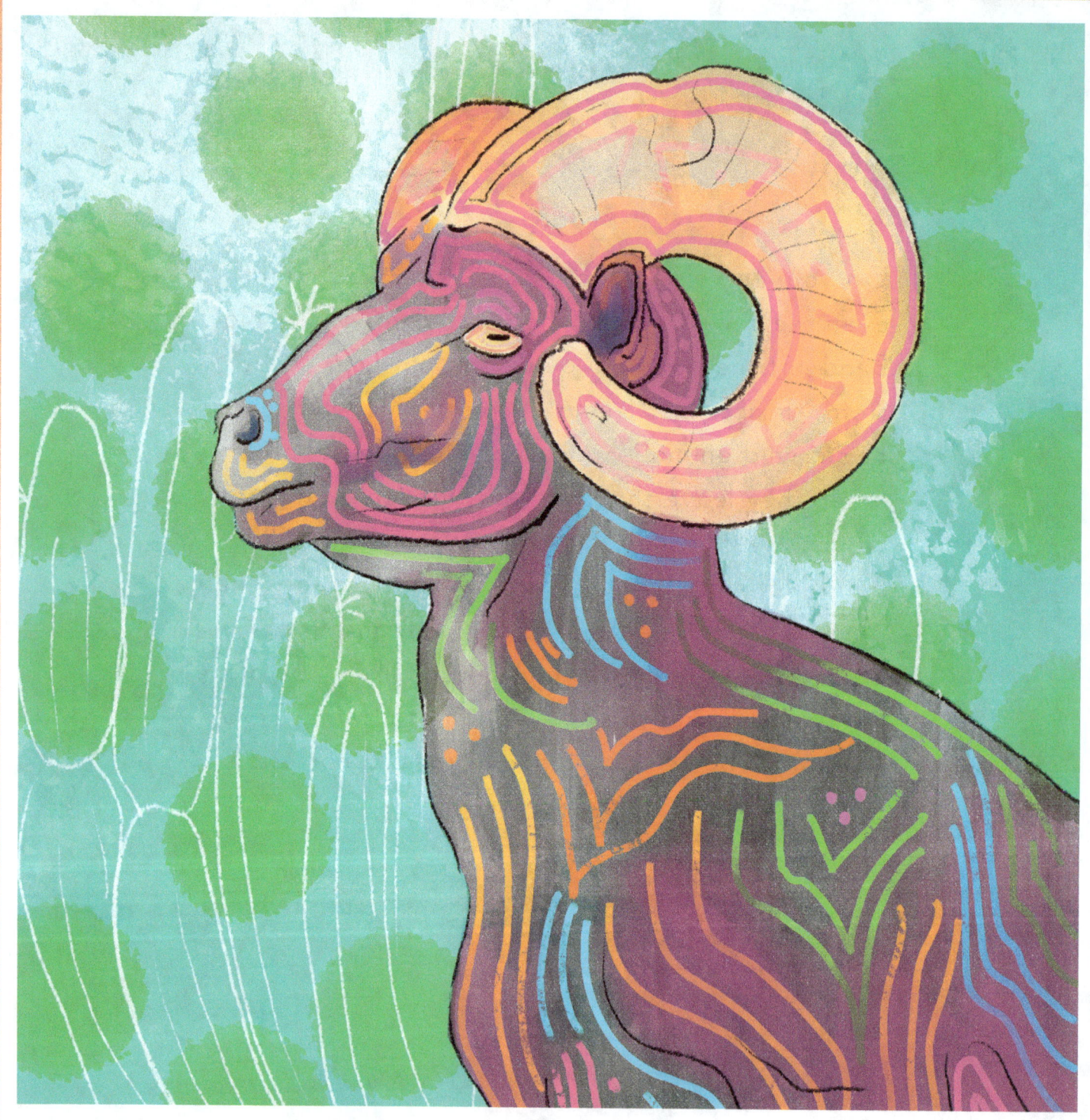

Another animal native to far West Texas is the bighorn sheep. You can find our friend in the Big Bend area. Bighorn almost disappeared in the 1960s but the Texas Parks and Wildlife Department has worked with other groups to help keep him safe. He lives in a family group called a "herd." Our friend Bighorn likes to live in rocky mountains where he can climb and play. He does have to share food and water with the Aoudad (another wild sheep) and the feral burros. Bighorn can be shy so you may not see him, but if you do it's a real treat!

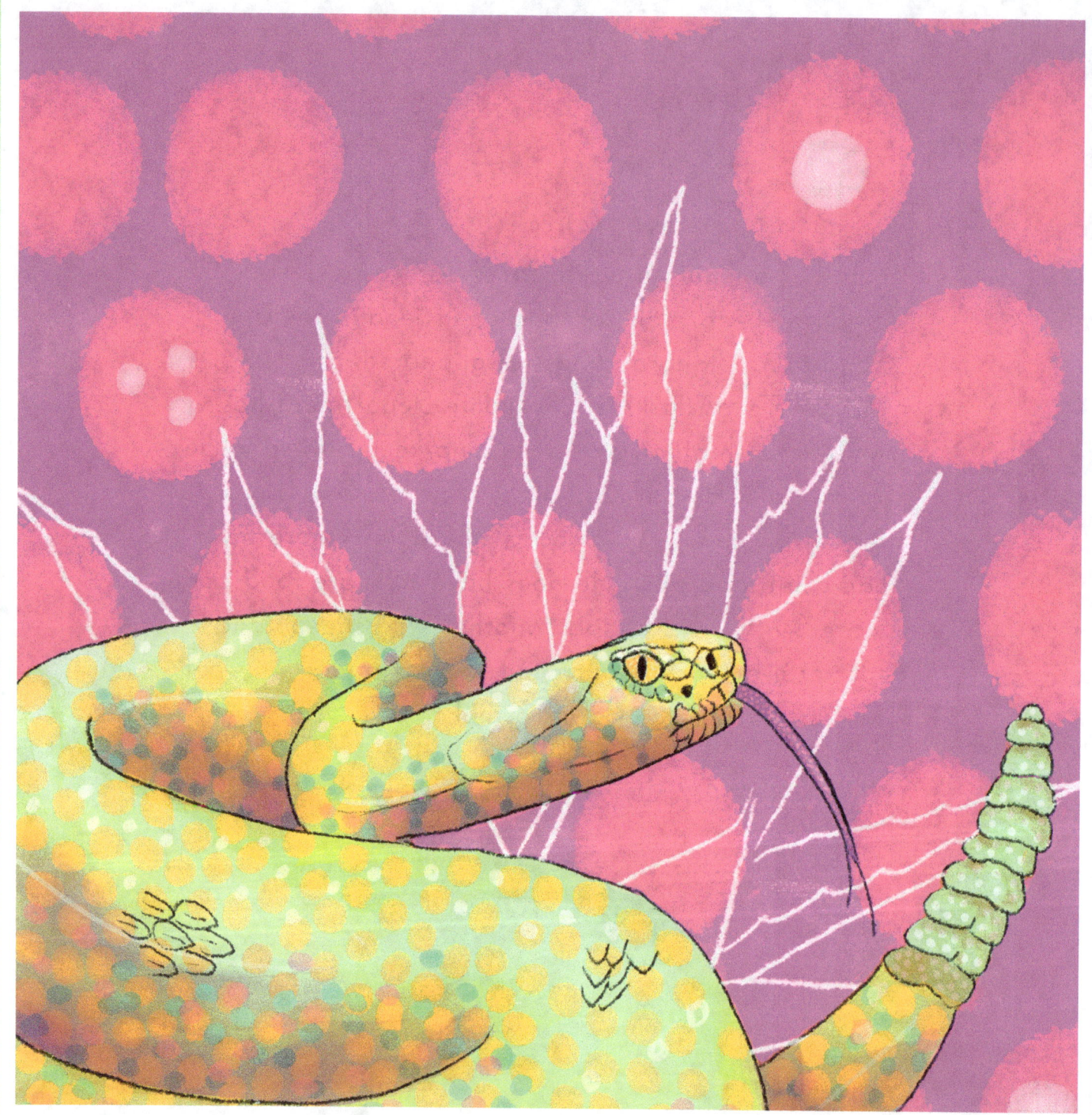

Our friend Rattlesnake is a venomous snake common to West Texas. She doesn't have ears, so she can't hear sounds; instead, she uses her other senses. She can feel vibrations in the ground around her and she has excellent vision. She is a pit viper - which means that she has a pit or a hollow area under her nose that helps her to locate her next meal. Rattlesnake does have predators too - she can be eaten by other snakes, roadrunners, coyotes, and other large animals. Rattlesnake's most distinct feature is the rattle on the end of her tail. This rattle is made of keratin - the same protein that makes up your fingernails. If you see her, she will tell you to leave her alone by shaking her rattle at you.

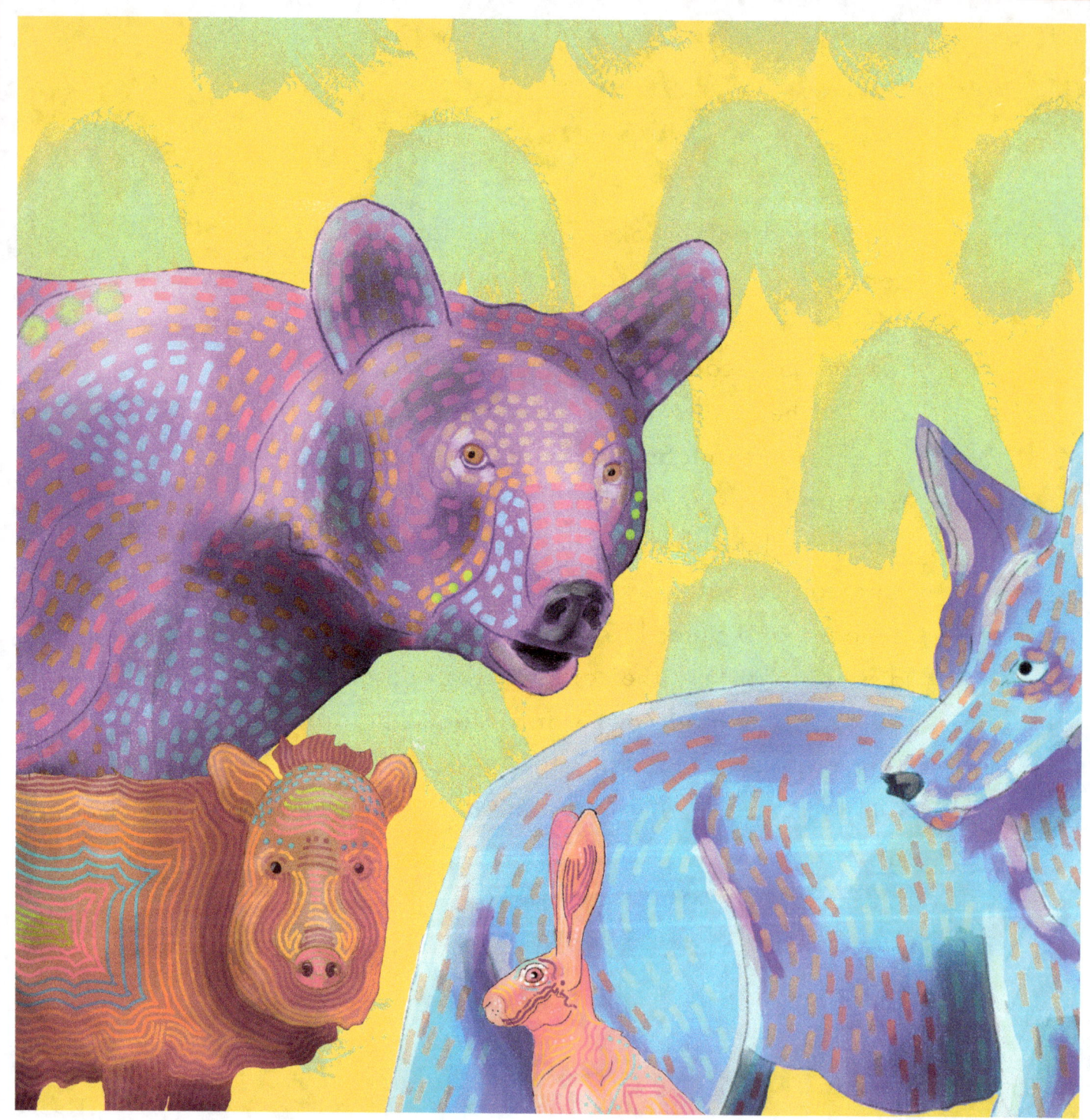

From Singing Coyote to Fast Roadrunner these are just some of the animal friends that you might see in West Texas. Remember that the best way we can learn about our animal friends is to give them plenty of space in their own home (nature). We can watch them from a distance that is safe for them and for us.

www.ingramcontent.com/pod-product-compliance
Lightning Source LLC
Chambersburg PA
CBHW081024170526
45158CB00010B/3151